Exploring Labyrinths:
A Mini-Tour
And
Coloring Experience

Debbie Hoskins

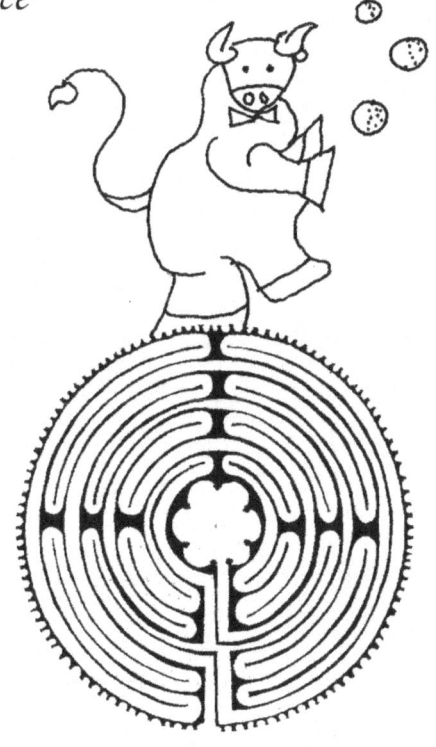

Special thanks to:
My husband, Reggie, who came up with the pun, "Mini-Tour."
It birthed many Minotaurs.
Becca's nose ring.
My son, Jesse, for his computer support, when he answers my panicked calls.
Dad, who kept asking me how my projects were coming along.
Mom, my chief proofer.
The other loved folks who hang around our house, who were forced to proof the proof.

Lorri Cardwell-Casey of Re:VISION Critiques for her great suggestions and midwifing.

CATALOGING IN PUBLICATION DATA

Hoskins, Debbie
Exploring Labyrinths: A Mini-Tour and Coloring Experience.
Copyright @ 2016 by Debbie Hoskins
All rights reserved.
Includes bibliography.
ISBN: 1537188852
ISBN-13: 978-1537188850
1. Labyrinth– Juvenile literature. 2. Labyrinth—Coloring book.
3. Labyrinth—Juvenile Non-fiction. 4. Coloring Books for Grown-Ups.

Dedicated to observing the power of the labyrinth.

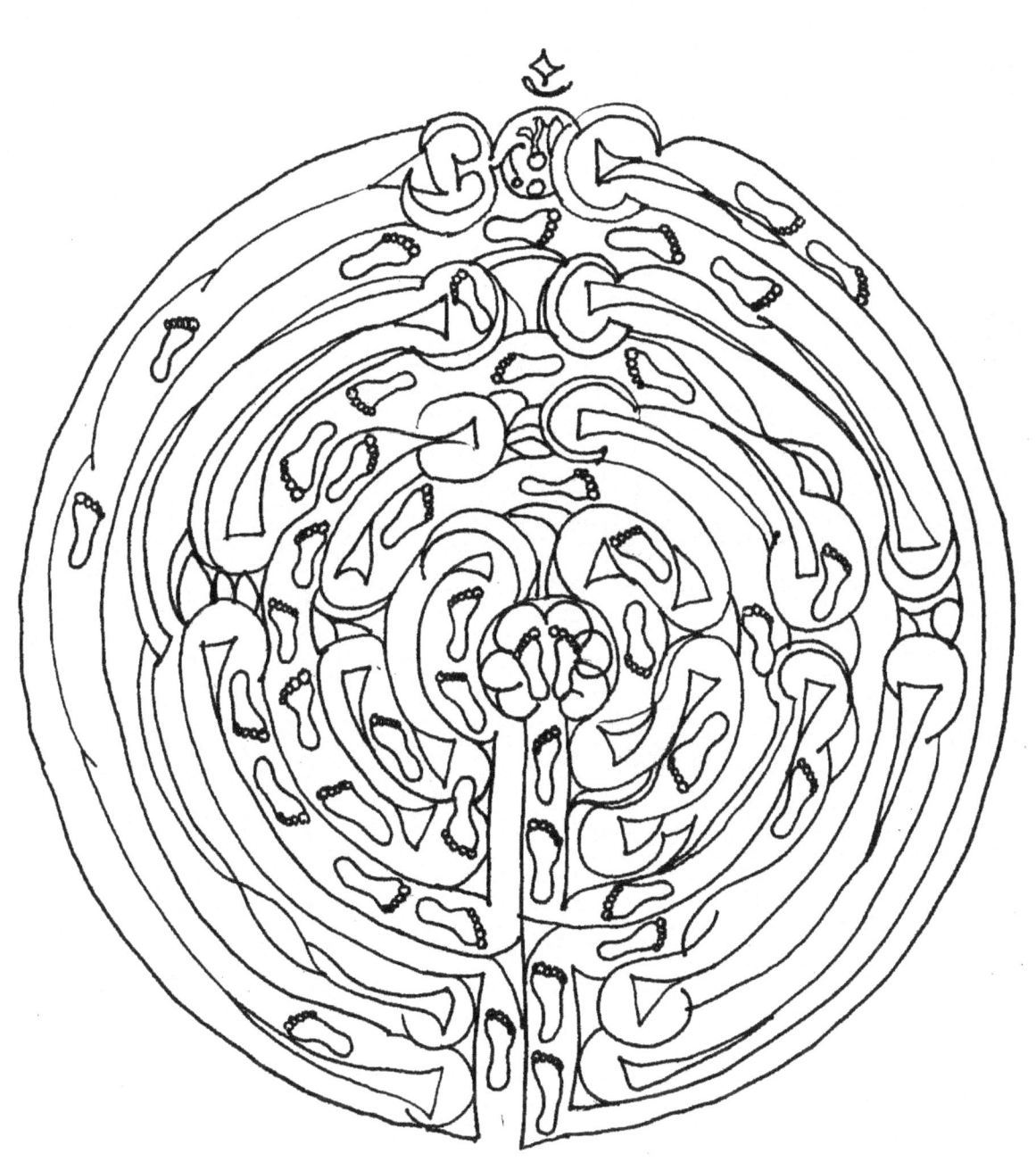

The labyrinth is a meditation tool.
To walk a labyrinth,
no rules are needed.
Follow your own path.
Move any way you choose.
Crawl,
stroll,
skip,
dance,
or run.

A labyrinth can be walked
alone or with others.
At ArtPrize in Grand Rapids, Michigan,
the community built
a labyrinth
out of tape and chalk.

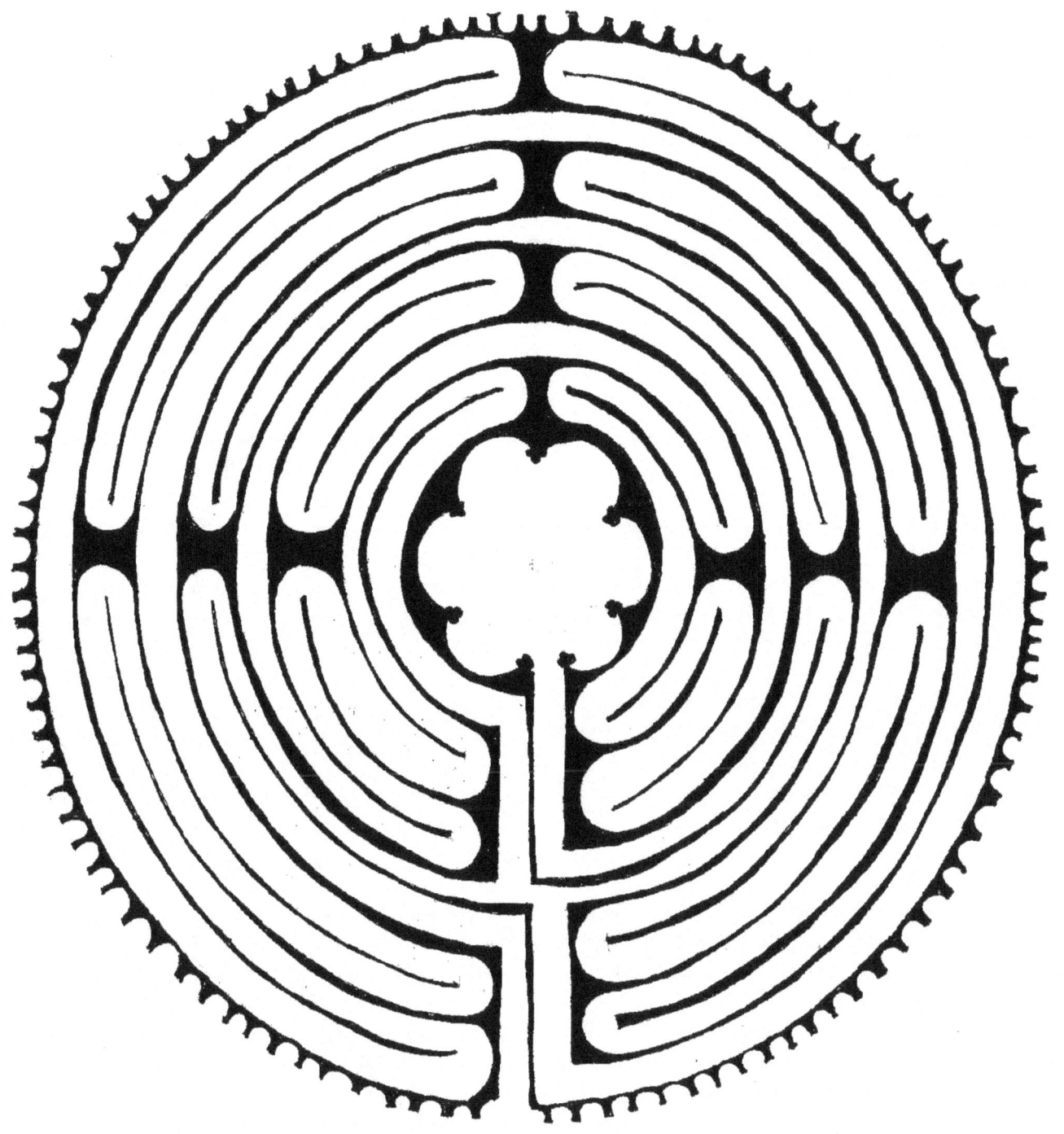

The Minotaur comes
from a Greek myth.
He was half-bull and half-man.
After misbehaving,
he ended
inside a labyrinth.
The complicated design prevented
his escape.

A labyrinth is not a maze.
A maze is a puzzle,
created to confuse
you and make you
lose your way.
A labyrinth uses
one path.
The circular path
leads from the edge to
the center,
then back again.

Labyrinths exist
all over the world
and far back into history.
In Ireland, one labyrinth
dates back to
4000 B.C.
This is 500 years older than Sumer,
the first known urban civilization
(3500 B.C.)
Who made it?
Why?
It remains a mystery.

The Classical labyrinth
comes from the
island of Crete,
where it is told the
Minotaur lived.
This design is at least
five thousand years old.
Exactly how old?
Another mystery.

How to Draw the Classical Labyrinth.

Experiment using your non-dominant hand to go through finger labyrinths or those you draw. When you are comfortable drawing the labyrinth, draw with your non-dominant hand. Is it an exercise in letting go of control?

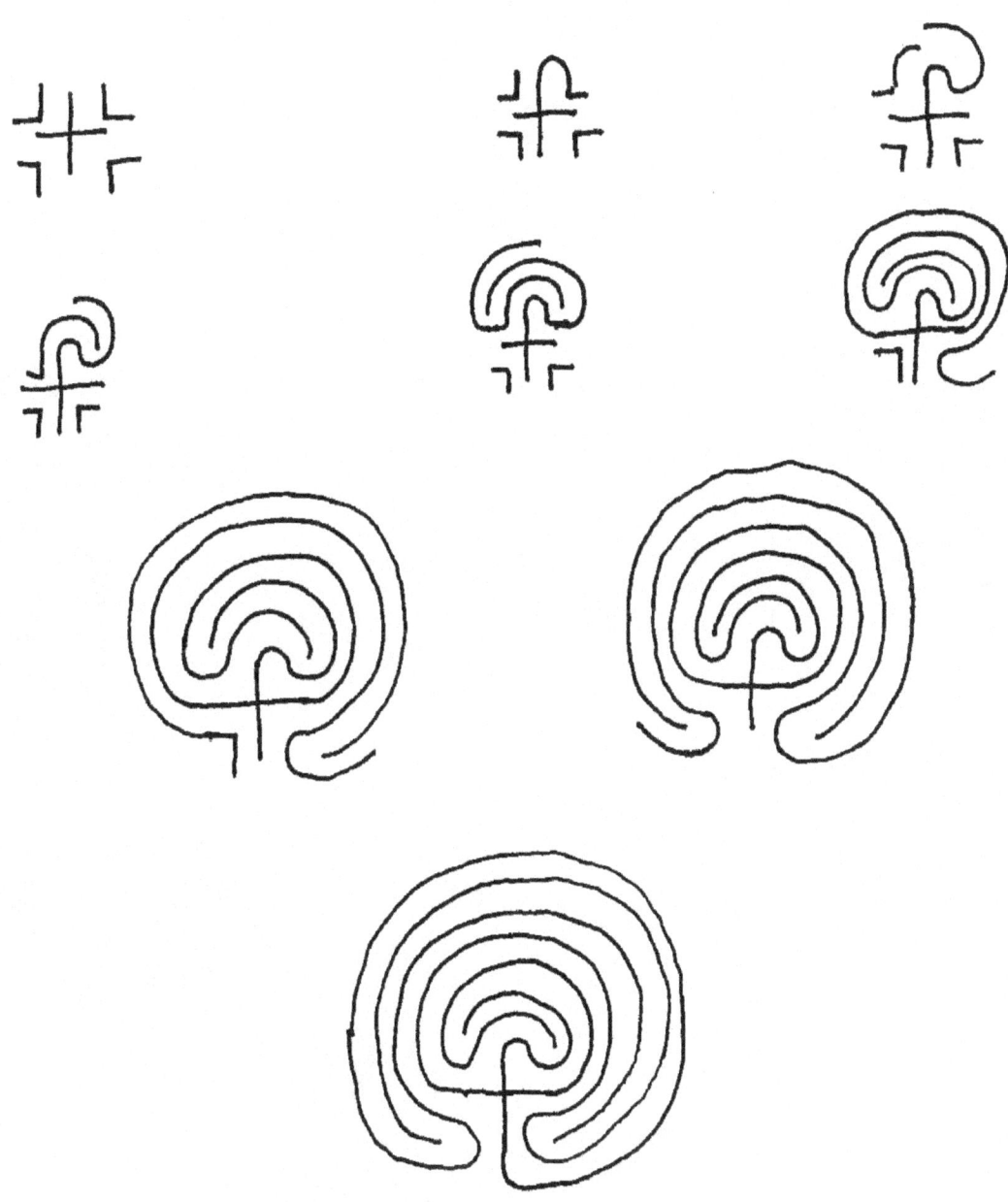

Many of today's
labyrinths are based
on an early thirteenth-century design,
found in Chartres Cathedral,
a Catholic cathedral in Chartres, France.
At that time, skilled workers
never signed their work.
No one knows who designed and built
this labyrinth–
yet another mystery.

Follow the Numbers to Understand and Draw the Chartres Labyrinth.

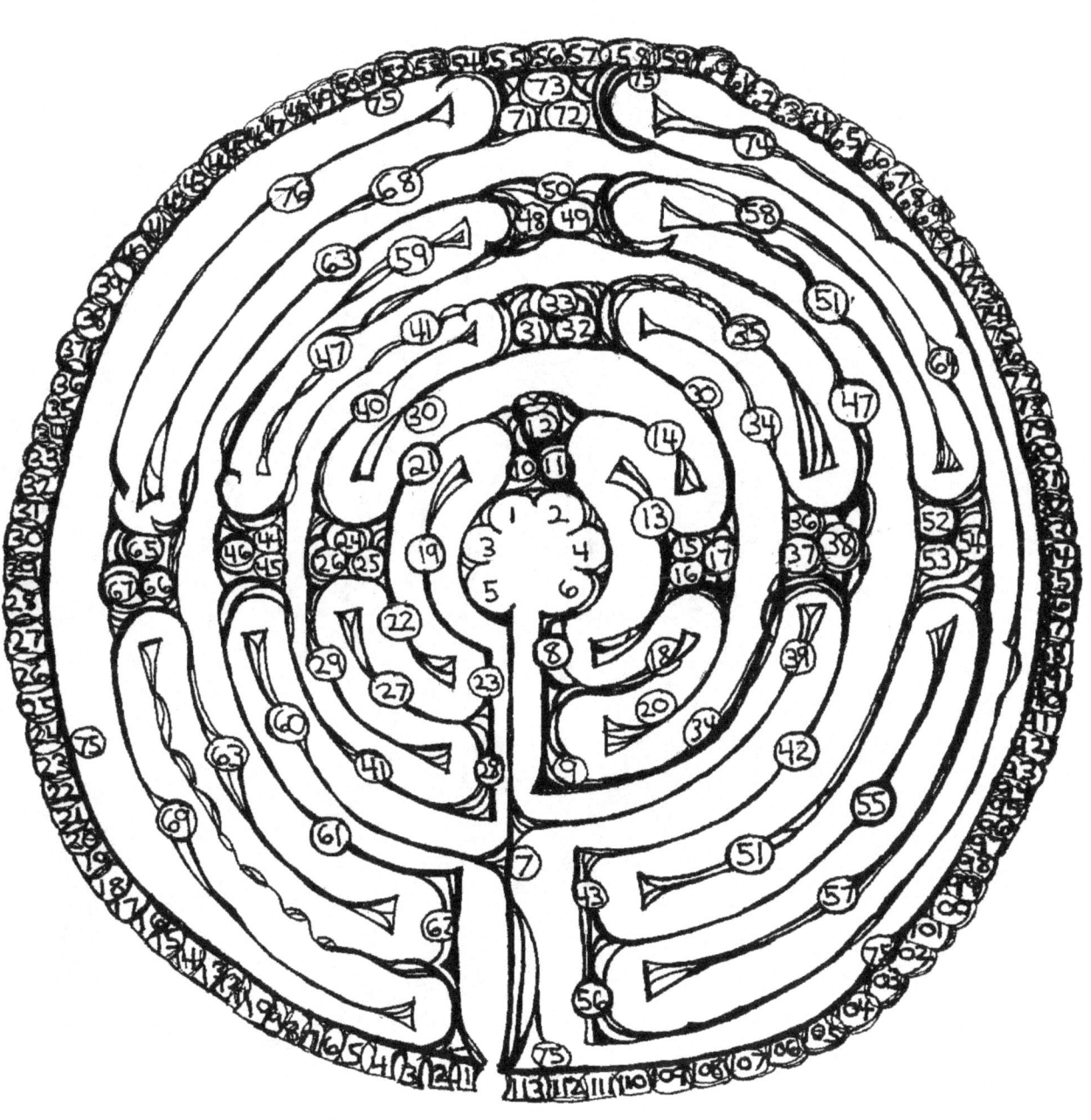

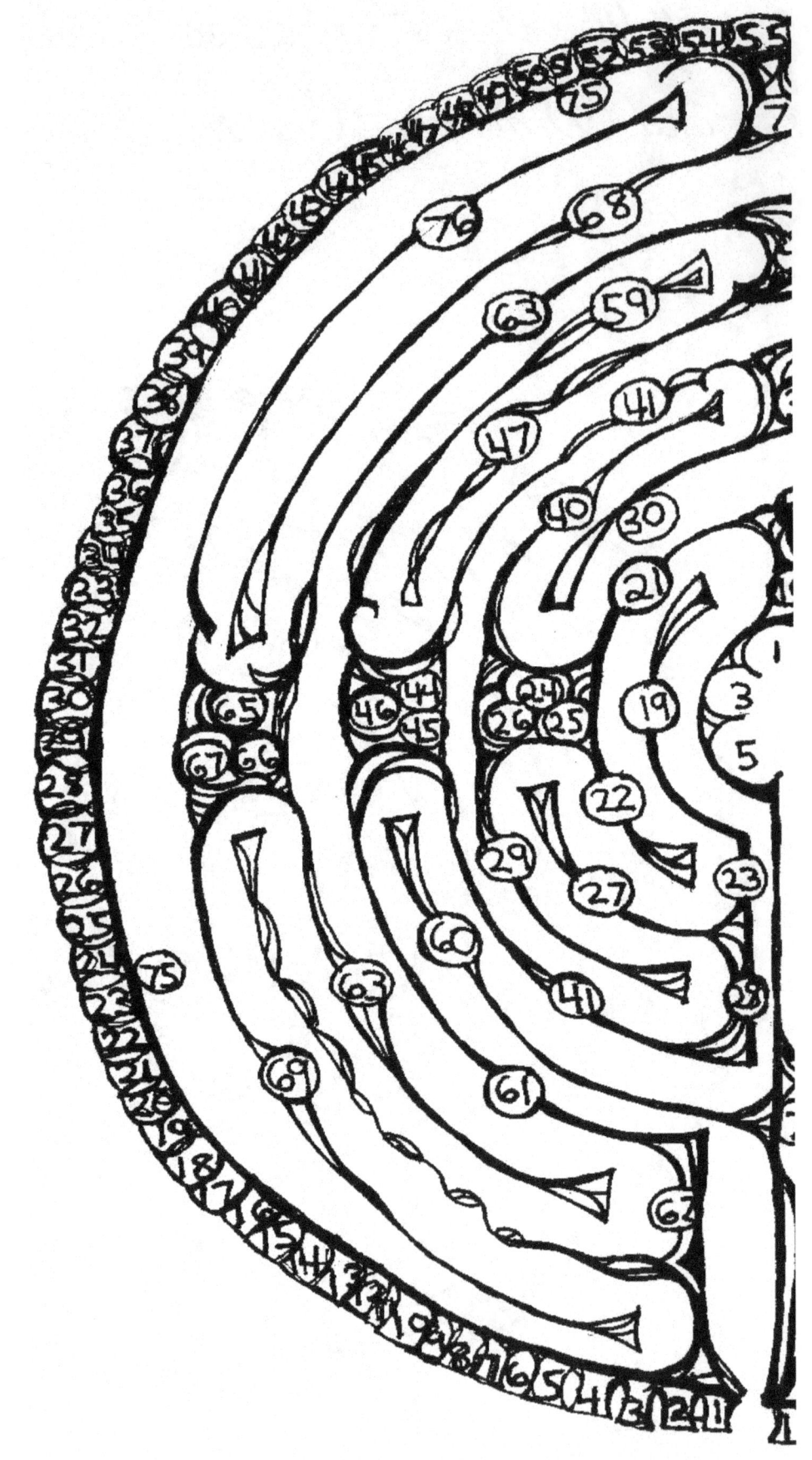

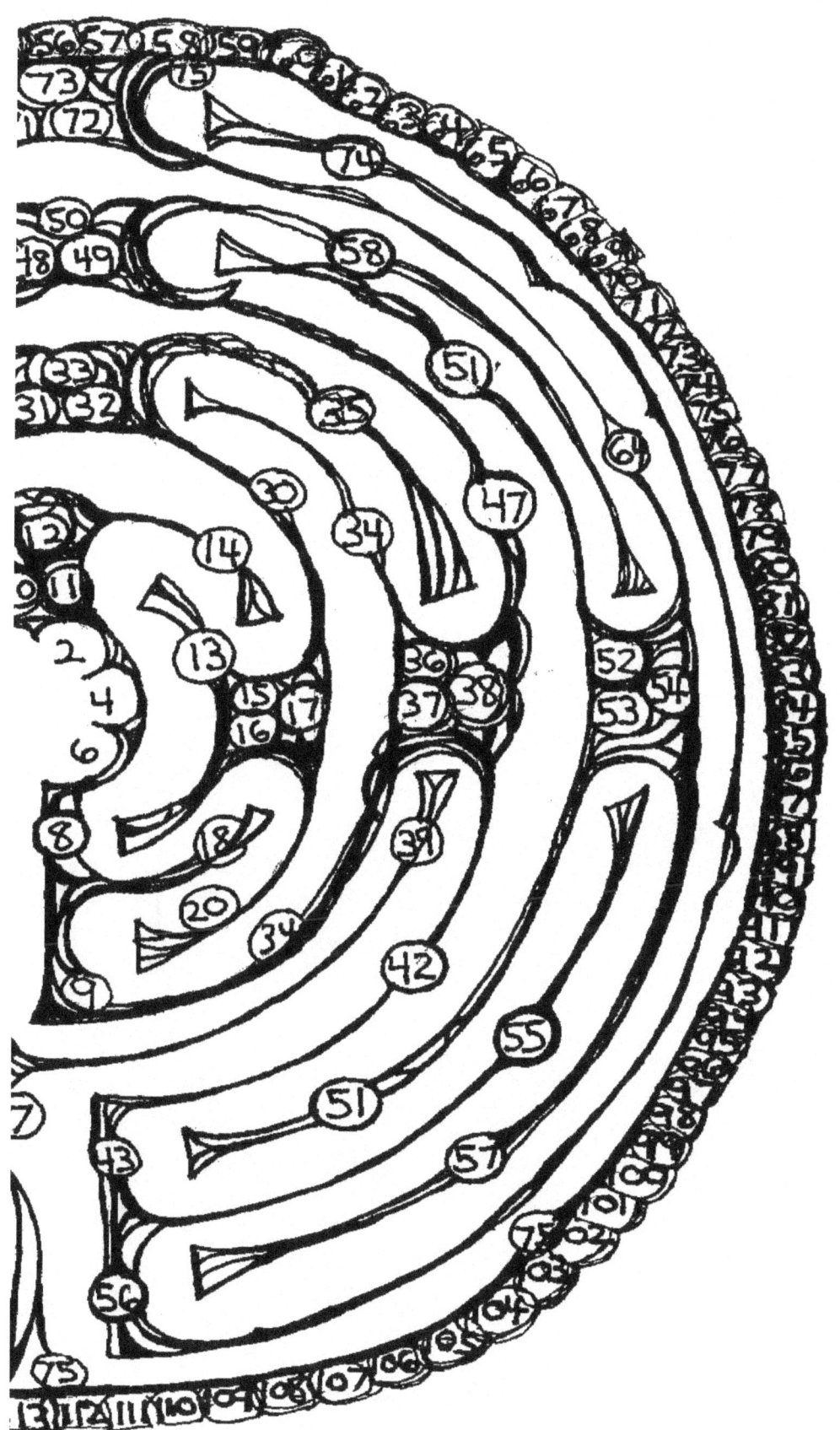

You can see labyrinths in
many kinds of buildings—
from the religious structures of many
faiths to hospitals, headquarters for organizations,
park facilities, and other settings.
Over 105 doctoral dissertations,
medical journal articles,
and research conducted in the last 24 years,
prove walking a labyrinth
reduces stress,
heals both physical and emotional issues,
and deepens spirituality.
A labyrinth can be a sacred place,
where some choose to pray.

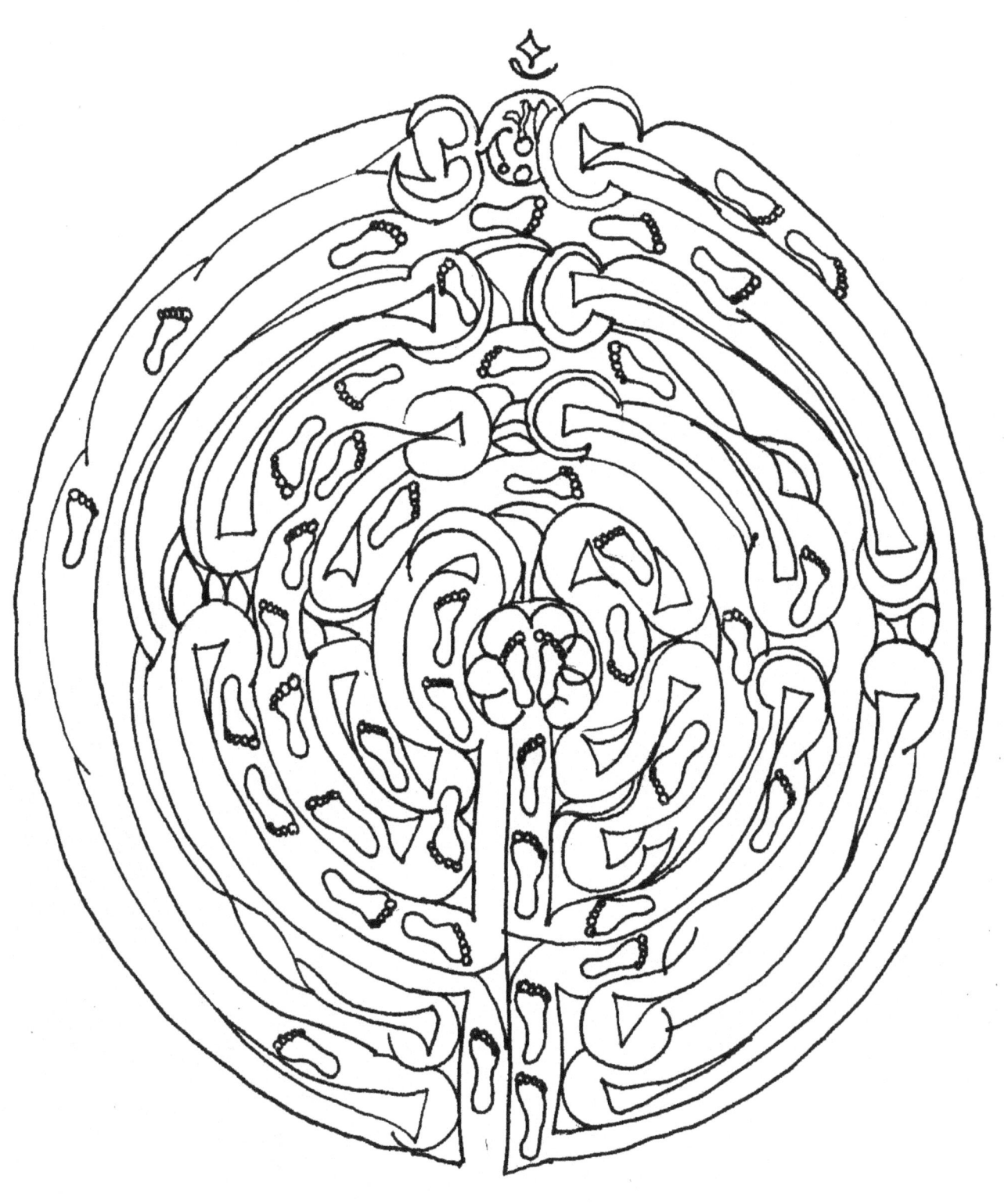

You can walk
a labyrinth when feeling
happy,
scared,
mad,
or sad.
You can blow bubbles.
You can bring gifts—
from balloons
and flowers
to tea light candles.
You can hum or sing.
Or, you can choose
to stay silent.

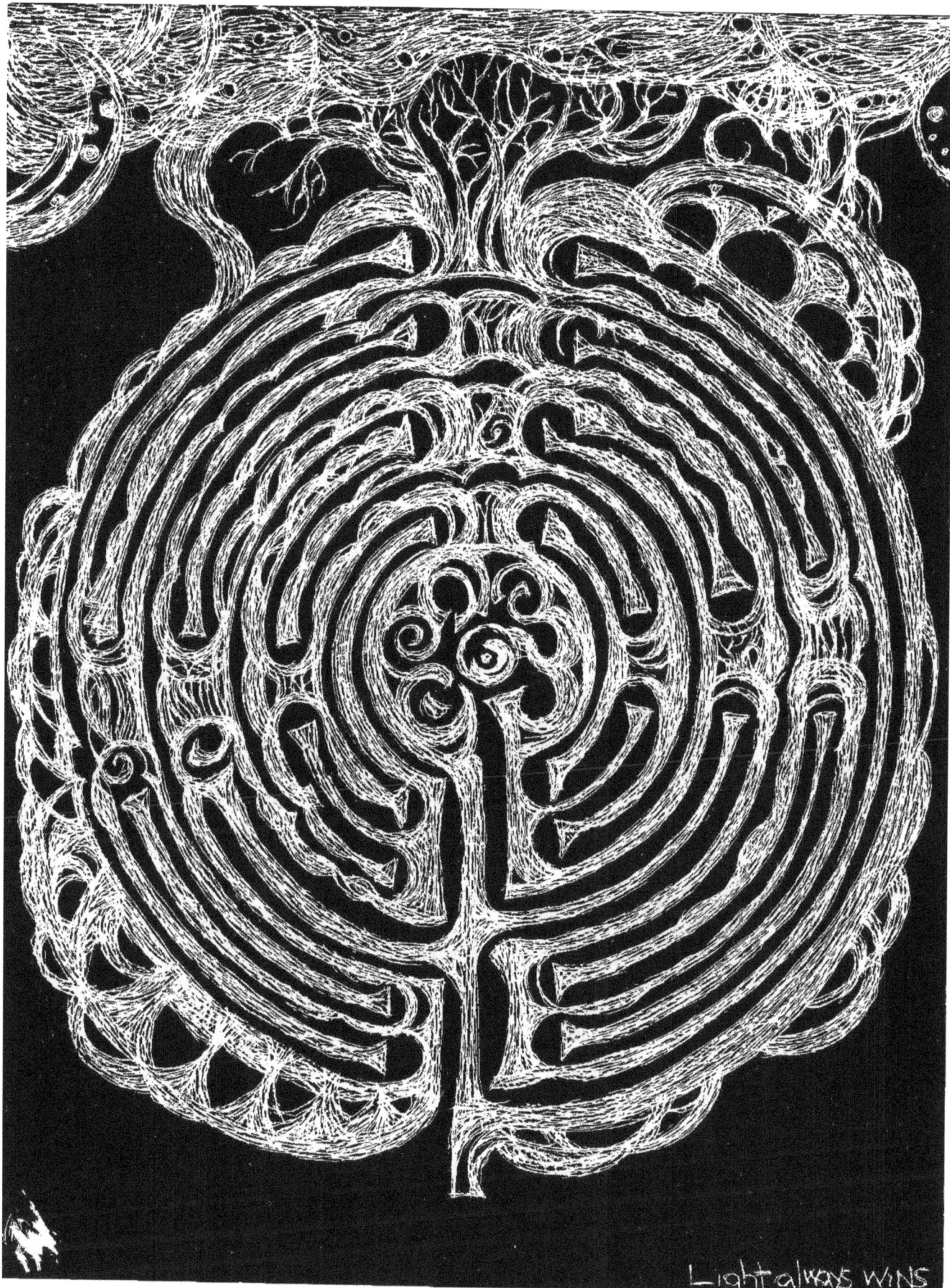

Light always wins

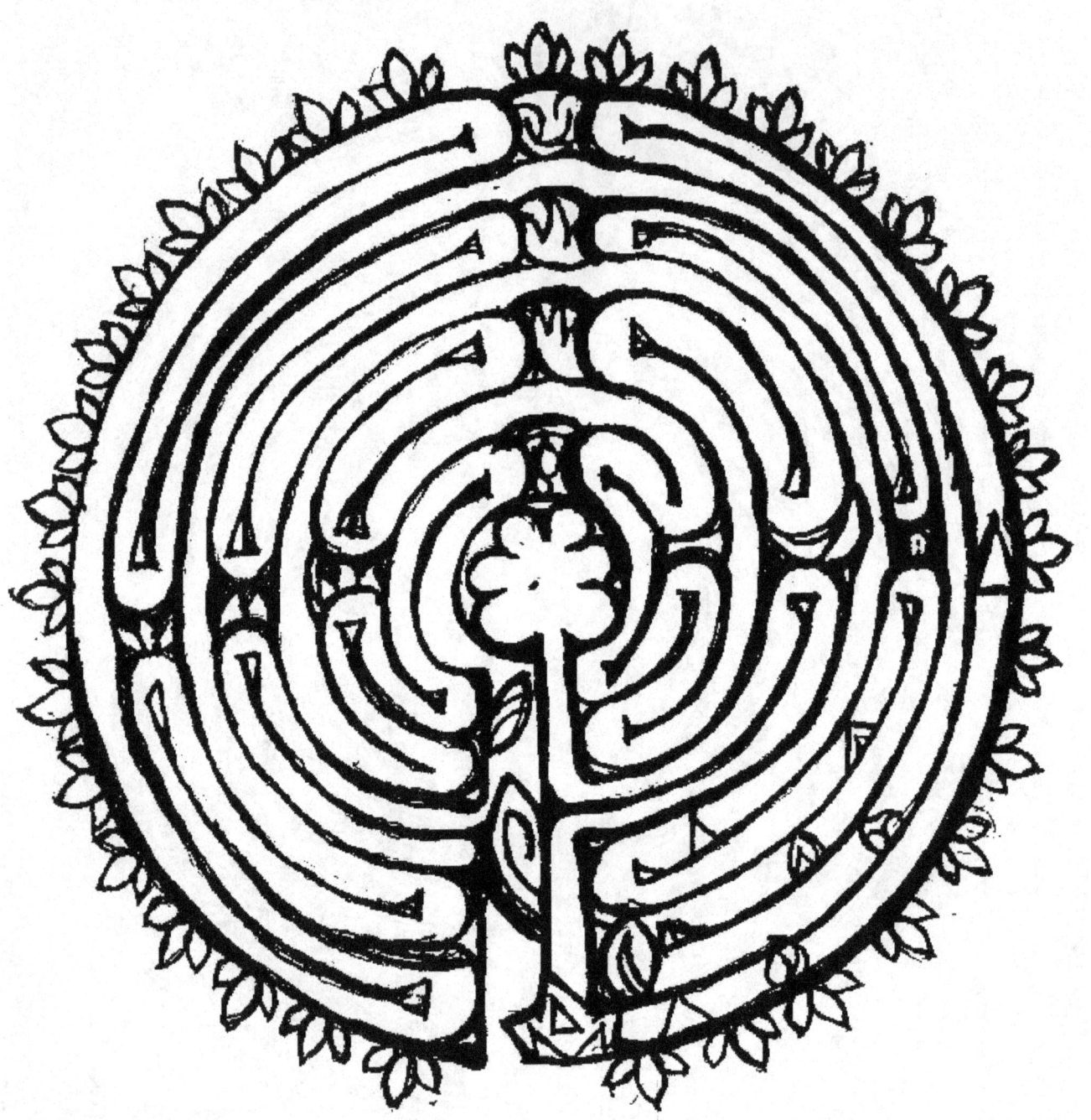

Further Reading

BOOKS:

Dalberg, Lana. *Birthing God: Women's Experiences of the Divine*. Woodstock: SkyLight Paths, 2013.
This collection of interviews illustrates the current practices and views defining Feminist Theology. The women are of different faiths and many are seminary graduates and have Doctorates in Religion. Following each interview is an activity that involves meditation and relaxation techniques, including walking a labyrinth.

Gimbautas, Marija. *The Language of the Goddess.* New York: Thames & Hudson, 1989.
Scholarly, archaeological information about Goddess-worshipping, earth-centered cultures in the ancient world. Documents labyrinthine designs that have been discovered.

Schaper, Rev. Dr. Donna and Rev. Dr. Carole Ann Camp. *Labyrinths from the Outside In.* Woodstock: SkyLight Paths, 2013.
The most recent book published about labyrinths. The authors express their unique knowledge, views, and experiences with labyrinths.

WEBSITES:
ArtPrize.org
An open international art competition decided by public vote and expert jury in Grand Rapids, Michigan.

LabyrinthSociety.org
The Labyrinth Society website has events, research bibliography, and a convenient link to the World-Wide Labyrinth Locator sponsored by the Society and Veriditas.

Veriditas.org
Veriditas is a non-profit organization committed to offering the Labyrinth experience throughout the world. They train and certify Labyrinth Facilitators.

About the Author: Debbie Hoskins

A certified labyrinth facilitator,
life-long notebook keeper,
music lover, and dancer,
my current prolific period of
drawing grows from the design
of the labyrinth. I post a picture with
words and thoughts for the week at
Facebook.com/DebbiesHomeStudio.org
My website is at debbiehstudio.org.

My artwork career includes three solo
art exhibitions, illustrations for
five as-yet unpublished picture books,
and work exhibited in numerous
juried shows held in Philadelphia,
Pennsylvania and Grand Rapids,
Muskegon, and Detroit (all Michigan).

I received my Bachelor of Arts
in Music (Cum Laude) from Kent State
University/Ohio and my Masters Degree in Library Services to Children
and Young Adults from Drexel University/Pennsylvania.
I am grateful for attending the following schools:
Columbus College of Art and Design/Ohio,
Pennsylvania Academy of Fine Arts,
Philadelphia College of the Arts,
and a Vassar College picture book publishing institute.

I am proud to have made my "daily bread" as a Youth Librarian.
Librarian privileges include taking care of materials offering art, story,
and knowledge to the community. A library is also a place where
everyone can use the bathrooms.

Though my art comes from an intuitive, spiritual place,
I'm also a Grand Rapids' Fat Boys burger kind-of-girl.

Last Notes:

When walking with others, there is one path
where others are starting and finishing.
I've observed that some look uncomfortable
and stop and wait for the other person to pass.
This is not necessarily so.
Be polite.
Try different ways to pass.
Choose what gives you peace.

In 2005, I went to a children's book author and illustrator
conference held at the facilities of the Adrian Dominican Sisters. Their labyrinth was the first I walked. Since then, I frequently draw labyrinths. I found other labyrinths to walk. In my backyard, I made two labyrinths.
In Cleveland, Ohio, I took labyrinth facilitator training from Rev. Dr. Lauren Artress. In 1991, Lauren and a group from Grace Cathedral, San Francisco, removed the chairs covering the Chartres Labyrinth. Today the chairs remain, but they are cleared and the labyrinth is walked regularly. Historically, the labyrinth is rediscovered periodically. In recent times the labyrinth was first found in contemporary fine arts of the early 1900's.

For certification, I needed to lead three labyrinth walks, each including more than ten people, and have my walks evaluated by separate people with labyrinth experience. Many of the places and people I contacted couldn't help me. But I kept e-mailing and making phone calls, with my application due November 1, 2015. At the end of October, I completed my final walk. I knew this timing showed the spiritual lessons, that I needed to do the footwork and to accept that if meant to happen, it would. It did! I am a certified labyrinth facilitator.

Now I have written and illustrated this book. Not many books for adults or children are published about labyrinths. The quiet, yet powerful spirit of the labyrinth transformed not only my art, but also prayer and meditation with my God. My hope is that this sharing may launch you into a meaningful labyrinth practice of your own.

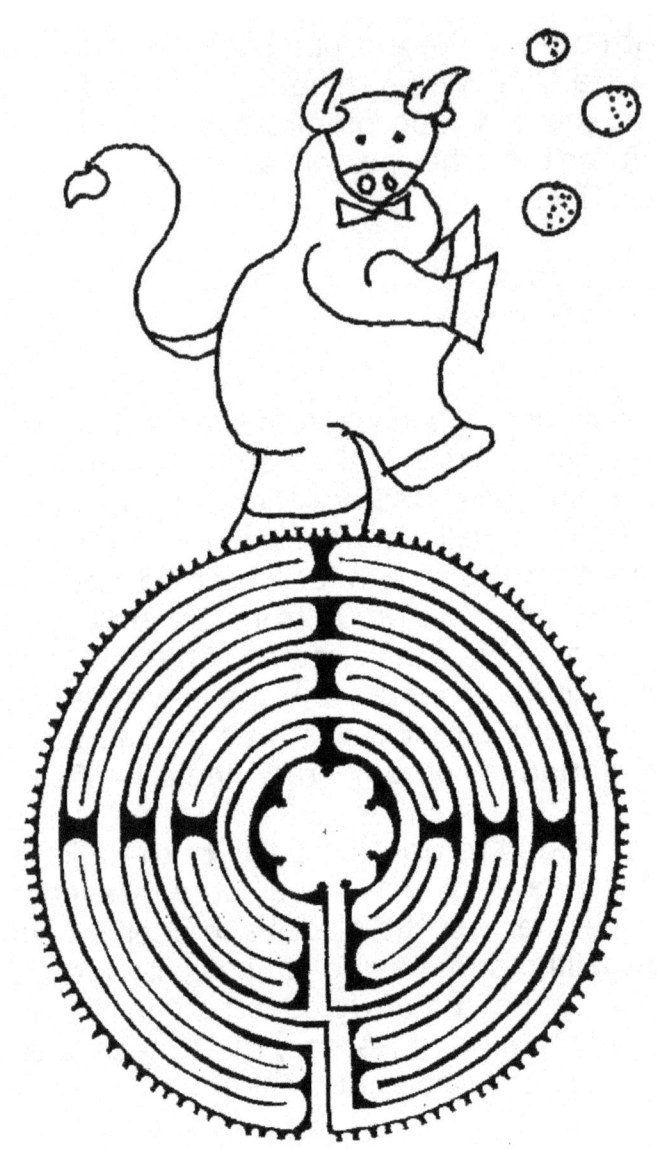

www.ingramcontent.com/pod-product-compliance
Lightning Source LLC
Chambersburg PA
CBHW080645190526
45169CB00009B/3514